THE
GENTLEMEN'S
ALLIANCE
CROSS
Arina Tanemura
Illustrations

THE GENTLEMEN'S ALLIANCE CROSS

ARINA TANEMURA ILLUSTRATIONS

Art of Shojo Beat Edition

Translation/Tetsuichiro Miyaki
Design/Carolina Ugalde
Editor/Nancy Thistlethwaite
VP, Production/Alvin Lu
VP, Sales & Product Marketing/Gonzalo Ferreyra
VP, Creative/Linda Espinosa
Publisher/Hyoe Narita

THE GENTLEMEN ALLIANCE -CROSS-
ARINA TANEMURA ILLUSTRATIONS
© 2004 by Arina Tanemura
All rights reserved.
First published in Japan in 2004 by SHUEISHA Inc., Tokyo.
English translation rights arranged by SHUEISHA Inc.

No portion of this book may be reproduced or transmitted in any form or by any means without written permission from the copyright holders.

Printed in Singapore

Published by VIZ Media, LLC
P.O. Box 77010
San Francisco, CA 94107

First printing, November 2009
Second printing, November 2009

Afterword

This is my third art book. Ever since my first, I've been putting all my effort into the illustrations so that I would not regret it if I ever got the chance to publish another art book. (I took the liberty of omitting all the illustrations I regret.)
The Gentlemen's Alliance † was slightly more grown-up than my other series, so this collection is a little more chic compared to my other art books as it sums up the entire series.
The series lasted four years, so you can see the type of color and coloring technique I was hooked on at the time, which is a bit embarrassing. But I think that's one way to enjoy this book.
I hope to strive even harder, and I'll continue to draw more so I will be able to come up with a fourth art book.
Thank you very much, everyone.

62-A
Ribon, Dec. 2004, Announcement Illustration

The small Okorimakuri-kun is the highlight of this illustration. I usually have the character smiling in my announcement illustrations, but this is a rare one with Haine-chan not smiling. If you imagine what kind of posture she's in from the parts of the body which cannot be seen, she may not be smiling because it's so uncomfortable.

62-B
Ribon, May 2005, Magazine Cover

The underwear should never show. Even in a situation where it actually should be visible, it should not be seen. That is a rule of mine.

62-C
Ribon, Sept. 2004, Spine Illustration

I hadn't completely decided on what kind of hairstyle to give Haine yet at this point. This was on the spine of the magazine, so maybe there are quite a lot of people who never saw this?

62-D
Ribon, Mar. 2007, Announcement Illustration

More strange clothes... Haine-chan, you don't have to be this nice... You do have the right to refuse wearing it, you know?

62-E
Ribon, Dec. 2005, Announcement Illustration

An illustration with the winter uniform. I liked it, but I didn't have much chance to draw it.

62-F
Ribon, June 2005, Furoku Book Cover

I like how lively Haine-chan and Takanari-sama look in this. How many of you used this book cover? I'm one of those people who don't use it and store it away.

61
Ribon, July 2005, Title Page

I wanted to draw something with a lot of shade, but I also wanted to give it a cool atmosphere, so I used a purple that looked almost gray, rather than using the usual yellow and pink colors. I always color in the shading first. That's because the colors tend to blur if I do the shades after coloring the other parts. This is a rare illustration in which the content of the picture fit the mood of the chapter.

61
Ribon, Mar. 2005, Title Page

I put a lot of effort into drawing the differences in physique between Riko and Tsukasa. I'm very satisfied with the color of Toya-kun's uniform and found myself entranced by the light blue. I didn't do a rough sketch for the background—I just randomly drew it.

THE GENTLEMEN'S ALLIANCE CROSS
Arina Tanemura Illustrations

64
Ribon, Jan. 2005, Furoku Calendar

I took a long time drawing this. I like the shade of the colors. Was Maguri this kind of boy? (His clothes are completely over the top.) I used a little bit of the flashy fluorescent pink that I don't use very often.

63-A
Ribon, Mar. 2006, Furoku Message Board

I drew this to look like a school graduation. (That's what the furoku was about.) Is the color a bit too dark?

63-B
Ribon, Dec. 2004, Zen-in Drama CD Illustration

The tie looks nice, doesn't it? The drama CD was a memorable experience. The black part of the uniform seemed to stand out too much, so I made it lighter in this illustration, but I decided to go with the original darkness in the end. That's a pretty rare thing for me.

63-C
Ribon, Apr. 2005, Furoku Notebook

Quite a number of you may not know this. This was drawn when these two were not that lovey-dovey, so there was something very exciting about drawing this. They're in their own world.

63-D
Ribon Summer Holiday Surprise Extra Edition 2004, Furoku Poster

To be precise, it's Takanari, but it says Shizumasa since this is when he was still a double. Actually the English written on the original illustration was wrong, so I had them fix it when it was printed. Each one looks like a bookmark, doesn't it? I really enjoy drawing and looking at illustrations that have been separated into small sections like this.

THE GENTLEMEN'S ALLIANCE CROSS

Arina Tanemura Illustrations

57-A
Ribon Exciting Summer Festival 2005, Postcard

I tried to draw something like a futuristic bodysuit. I like the whiteness about it. The sea in the background represents the primitive age. It looks like a simple illustration, but a grand theme is actually hidden within it... She's sitting on a glass globe.

57-B
Ribon, June 2006, Announcement Illustration

I picture Kusame being like a cat (like his eyes). I wanted to make him look a bit grown up in this, but he's far from being a sexy character, so it didn't work out. But that's what's good about him, isn't it? He likes to play with his friends rather than go out with girls.

59
Ribon, Mar. 2008, Title Page

To let you in on a secret, I drew this with the image of the characters riding on the back of a shining dragon in mind. It was supposed to look a lot cooler, but... Well, I guess Ushio and Takanari...look okay. Every now and then I suddenly get the urge to draw a fantasy piece.

57-C
Ribon, Sept. 2004, Announcement Illustration

When you do so many illustrations in color, you start having trouble deciding on what color to use for the background. That's why this has such a strange background... This is the very first illustration for *The Gentlemen's Alliance †* in color. Where did I get the idea of drawing a Japanese sword...? I guess it's because she's a fighting girl.

57-D
Ribon, June 2006, Magazine Cover

This illustration solely exists for mini-Komaki. This is the closest I've gotten to my image of what Kusame would be like in color. But there is too much black in the illustration once they swap the ribbon and tie. I should have made it red.

60-A
Ribon, Dec. 2005, Postcard & Poster Prize

An angelic Haine-chan. The frame on the right is a sticker. Her hair color is different than usual. I like this illustration. The color is a bit plain, but the request was to include "Merry Christmas" in it, so I stuck a sticker on it and pressed the "Merry Christmas" stamp on that. Please notice that the words are sideways.

58
Ribon, Jan. 2008, Title Page

I like the cross pendant Haine-chan is wearing. It's an image of the three lying down as if in a field of flowers, but for some reason Haine-chan is dressed too lightly. The white spots were drawn with a white pen, then I blotted them using a waterbrush.

60-B
Ribon, Dec. 2004, Christmas Card Prize

I wanted to give this illustration a border to make it look like a stamp, or like the image on a bank note... So what do you think? I like drawing fur. It's difficult to draw, but it adds a softness to the illustration, so I still challenge myself to do it. I want to draw this white Santa Claus look again if I get the chance. This Christmas card prize takes place every year at *Ribon* magazine, and mangaka swap their postcards with each other.

60-C
Ribon, July 2006, Furoku Postcard

An illustration that seems to have no connection to a summer postcard. Haine's clothes were a bit too detailed, so I had a tough time drawing the outline with a pen, then coloring it. I'm not very fond of green per se, but I love emerald green. My favorite colors are pink, red and then pale yellow.

THE GENTLEMEN'S ALLIANCE CROSS

Arina Tanemura Illustrations

53 — *Arina Tanemura Calendar 2006, Front Cover*

At first glance you have no idea what this manga is about. Maguri is even wearing a ribbon! I wanted to make this illustration white, but then why do I keep making them colorful all the time? I like the staffs Haine-chan and Mao-chan are holding, and Ushio-chan's sassy posture.

54 — *Ribon, May 2008, Title Page*

An image of fighting Haine-chan, which I had not drawn for some time, holding a sword. I don't like to use black for the night sky, but I thought black was the only color to use here! So I broke that taboo. I hope you can sense some kind of atmosphere from it.

55 — *Ribon, Apr. 2008, Title Page*

An illustration I did because I wanted to draw Komaki. I used colortones for their clothes, but when it was in the magazine, Haine-chan's skirt had been cut off and looked bright white…which I turned pale blue. I always have a lot of fun drawing small objects.

56 — *Ribon, June 2006, Bonus Story Title Page*

Hmm… The coloring lacks something… I don't like it. What a pity. Komaki's funny-looking dress is the only thing I like about it. I pasted colortones on the balloons. The bonus story this accompanied was probably the best I've ever done. So that makes me even more frustrated.

51-A — *Ribon, Oct. 2004, Furoku Postcard*

This is one of the earliest illustrations. I have good memories of it—the light coming in through the window turned out much nicer than I had imagined. Haine-chan is sitting on her hair. I first used a Copic airbrush to spray on the shadows, then I colored it. (But I colored the skin before using the airbrush.)

51-C — *Ribon, Sept. 2005, Furoku Plaque*

I drew this in the image of a commemorative photo. By looking at the picture, you can have a rough idea of around what volume I drew this—like how Maguri and Mao-chan are not in a relationship yet. To tell the truth, I'm not good at drawing people of the same size all lined up together… It was very tough because there were a lot of situations when the five of them were together.

51-B — *First Edition Postcard for Volume 1*

This is an illustration I drew when volume 1 came out. What was I trying to do with Maora…? I thought Haine-chan would look good in a tie. So it's a pity she had to change it with a ribbon in the middle of the story. (Hey!) I know it couldn't be helped, but it's still a pity.

51-D — *Ribon, Feb. 2007, Announcement Illustration*

I like this illustration a lot. The pink used for the uniform stands out well, so I had a fun time drawing it. The request from the editorial department was to do an illustration which looked like she was "whispering in your ear." She has long hair… Aah, the memories…

52-A — *Ribon, July 2007, Furoku Calendar*

The request I got was, "Something pink with an umbrella," so I used the umbrella in a strange way, and they liked it a lot. I think it would hurt if you sat on it like this, but don't worry, our Haine-chan has guts. I stuck colortone on top of the area immersed in water.

52-B — *Ribon, July 2005, Furoku Postcard*

My sense of summer is that it's a lonely season. The sound of the cicadas are so loud that I get the feeling that it's wiping out my existence. That's what this illustration is about.

52-C — *Ribon, Oct. 2004, Announcement Illustration*

I bought the "top secret" stamp just for this illustration. And I took a long time doing the shadows on her clothes. I'm sure you can sense the strong passion of starting a new series from this (as if it had nothing to do with me). I like the posture Haine is in, so I selected it for this book.

52-D — *Ribon, Oct. 2006, Announcement Illustration*

I just love the color. I didn't want to use yellow, so I made her eyes green.

48 — *Ribon*, Aug. 2007, Title Page

I wanted to roughen the edges of the illustration, but doing that on purpose is pretty difficult. It was drawn on mermaid paper, and the outline was done in pencil. Haine-chan must have gotten the strawberry from the Postman who just happened to pass by.

44 — *Ribon*, Jan. 2008, Zen-in Book Cover

You actually don't often see these three together in the same illustration. I like it because the design of Haine-chan's clothes turned out just the way I wanted it to. The upholstery of the chair she's sitting on looks very rough, but I wonder if that's okay…(for a chair, I mean). The roses are made from photocopies of screentones that I colored and stuck on the illustration.

40 — *Ribon*, Sept. 2007, Title Page

This title page was also a poster. This is a version of them all wearing yellow uniforms. I pasted each of the polka dots and then used them to get a masking effect…which made me wonder for a moment what my actual job was. It was done on mermaid paper. I like this one because Maguri turned out nicely.

49 — *Ribon*, Aug. 2006, Title Page

This was supposed to be a bright picture, so why did it turn out so lurid…? I drew this in the image of her looking over as she was walking. You can see confetti flying around, so maybe it's a parade?! I wanted to draw clothes in yellow and black. Please pay attention to the thickness of the sunflower stems.

44 — *Ribon*, Aug. 2005, Furoku Book Cover

The girls and boys are wearing very different kinds of clothes. Especially Maguri—what was he thinking? (laugh) What's that fancy hat for? I used a lot of black in my illustrations around this time.

41 — *Ribon*, Feb. 2008, Title Page

An illustration drawn during my "Let's Get to Like Green Campaign." (I'm not good at using green and orange.) Although I wasn't thinking about it back then, it kind of looks Christmassy, doesn't it? I thought Haine-chan would look nice in shorts, so I put my effort into making her thighs look nice.

50 — *Ribon*, Sept. 2006, Title Page

An illustration with Mao-chan and Haine together. Its color kind of reminds me of Girls' Day, doesn't it? I usually like to draw my cherry blossoms white, so I held back the strong urge of wanting to color them. When I use an airbrush on top of the characters, I only mask their faces.

45 — *Ribon*, Feb. 2007, Title Page

I wanted to draw strange-looking clothes. My supervisor told me that she kind of looks like Nightingale, to which I thought, "Don't you mean Nurse?" The colored stars above Haine-chan are from masking tape I reused to get the effect in the background.

42 — Volume 10 Special Edition Book Case

I wanted to make the color look glitzy, so I did the background in red and black. I first used an airbrush to paint the red color on, then masked it and sprayed the black over it. I colored the eyes in the way I used to do eyes in the past, but what do you think? I wonder if it looks better this way…

THE GENTLEMEN'S ALLIANCE †CROSS

Arina Tanemura Illustrations

46–47 — *Ribon*, June 2006, Furoku Poster

This is a strange illustration. Why is Ushio-chan flying? This poster was put up on a wall in my parents' house, so it reminds me of my parents' house when I see it. I like the interesting effect in the background. I just love lace.

43 — *Ribon*, Nov. 2006, Title Page

The outline was done in pencil. It is supposed to be an image of Haine-chan wearing the yukata in a very casual, free way…but it's too casual! Your thighs are too tempting, Haine-chan! The point to note about this illustration is that I used blue for the window frame. I colored her eyes with red to make them look catchy.

THE GENTLEMEN'S ALLIANCE CROSS

Arina Tanemura Illustrations

33 — *Ribon,* Nov. 2007, Title Page

The outline is done in Dr. Martin's watercolor ink, and then I washed it out in a shower. That's how it got the strange translucent look. The color of the water in the background is my favorite color of blue ink, Dr. Martin's Radiant B21.

30 — *Ribon,* Oct. 2005, Title Page

Haine-chan is in a wedding dress because my friend got married. This is a rare illustration of her wearing lip rouge. The outline of the dress and veil was done in gray. I used Nouvel's Design Ink for the outline. I like the background green.

37 — *Ribon,* Apr. 2006, Title Page

I'm glad you can all see the area that was hidden with words when this ran in the magazine. This was around Valentine's Day, so that's why the chocolates are there. I also remember putting a lot of effort into coloring Haine-chan's choker. And her heavy-looking ring.

34 — *Ribon,* Mar. 2006, Title Page

The spattering really did the trick here. I think the theme for this illustration was "a strong visual." The white spatters are larger than usual to make them look a bit like drops of blood. I chose playing cards just because I wanted something to be scattered all over the illustration.

31 — *Ribon,* Apr. 2007, Title Page

The editorial department asked me to draw...the minibag zen-in. I used mermaid paper. The girls' school uniform for Imperial Academy is very colorful, so that in itself was like a trump card— just drawing the uniform would make the illustration stand out. I made the polka dots in the background by punching out screentones with a 6-hole punch.

38 — *Ribon,* Nov. 2005, Title Page

A very rare illustration of Maguri and Haine together. And to top it off, they're wearing the same clothes! What happened, you two? (laugh) I like the blue pattern behind Maguri's right shoulder. The illustration as a whole didn't turn out the way I expected, which is a pity.

35 — *Ribon,* June 2005, Title Page

This was the first time the winter uniforms appeared. The color turned out very nicely (maybe the paper takes gray ink well?), so it was a success. For the background, I colored the roses first and then pasted colortones on them. Now that I see it, Mao-chan's hair is a little too yellow, isn't it? I wonder why I did that...

THE GENTLEMEN'S ALLIANCE CROSS

Arina Tanemura Illustrations

39 — *Ribon,* Dec. 2007, Title Page

The outline was too light, and the color of the sky turned out too dark, so I'm not very satisfied with this one. (I'm just glad people have told me they like it.) When doing this, my thought was "white shirts in the sky!" But then again, Maguri is wearing a camp-print shirt... I want to redraw it one day.

36 — *Ribon,* Jan. 2006, Title Page

I drew this... because I wanted to draw the clothes. The background was mostly done with a Copic airbrush. The color is quite pink, and it turned out nicely when the illustration was printed. The masking effect done with the stars actually took a lot of time.

32 — *Ribon,* July 2006, Title Page

One of the few illustrations with the winter uniform. If you look carefully, you'll notice that the shirts the twins are wearing have a different neckline than usual. I used purple to color the areas that are usually in black to give the illustration a sense of wholeness. Haine-chan looks valiant in this because she had been depressed in the story during this time.

26 — *Ribon*, Oct. 2007, Title Page

The outlines were drawn in sepia and burnt sienna paint pigments, and I drew the hair and clothes with black ink diluted with water. It's pretty daring to draw people who are not the main characters for the title page illustration, but I was glad that readers liked it. Note that Kazuhito-sama looks sullen in this.

22–23 — *Ribon*, Mar. 2005, Furoku Poster

The theme of the illustration is "girly girls" (although one of them happens to be a boy). I colored it roughly to give it a ragged look, but what do you think of it? The Ushio drawn here is the closest to what I imagine Ushio is like. This is my image of her.

18 — *Ribon*, Apr. 2005, Title Page

This is an illustration I created with the intent of drawing something to represent the entire series. So I used black, white, and red. I've always been very picky about red, but I was picky about even the strawberries and skirt in this one. This is the kind of red I like!

27 — *Ribon*, Oct. 2006, Title Page

Drawn on mermaid paper, this is an illustration with a touch of fantasy. I'm very satisfied with how Mao-chan's sleeves are colored. Light colors come out nicely on mermaid paper, but I always have a hard time using dark colors on it. But I still use it because pinks turn out very nicely on it.

THE GENTLEMEN'S ALLIANCE CROSS

Arina Tanemura Illustrations

19 — *Ribon*, June 2006, Title Page

Of all the Gentlemen's Alliance illustrations I have drawn, this is my favorite. I was able to take my time drawing it, and it has a lot of movement. It's my highest-quality work. I first colored Haine-chan and the small objects in beige, then colored each one separately. Also, take a look at the band around the book.

28 — *Ribon*, Mar. 2007, Popularity Vote Result Illustration

I tried to make their eyes attractive in this. It's drawn on mermaid paper. This illustration is extremely popular. I colored their skin slightly darker than usual. For the darkest area of Komaki's hair, I used a brush-pen since the paper does not take color ink very well.

24 — *Ribon*, July 2007, Title Page

A collection of sexy-looking girls. But I didn't want their expressions to be sexy, so I had them all giving a sharp glance. When I first thought about how to compose the illustration, Haine was to be the largest. But after I drew the rough draft, I decided to draw Komaki larger. The girl whose mouth you can see in the bottom right corner is Kasuga.

20 — *Ribon*, Apr. 2005, Furoku Notebook

I draw Chinese dress at least once in each of my series. The editorial department asked me to do an illustration with Ushio and Haine, so I drew this to look like a photograph. It took some time to draw over in pen the rough sketch of the round pattern in the background. But I never seem to have trouble coloring things like that...

29 — *Ribon*, May 2006, Title Page

Surprisingly, the outline was done in pencil. I colored the clothes with a brush-pen and made highlights with a bit of water. When I said the outline was done in pencil, I did not mean I did the whole rough draft in pencil, but rather I traced over the rough draft...using a pencil. I wanted to make the illustration look rough. The loose hair was done in watercolor.

25 — *Ribon*, Jan. 2007, Title Page

For some reason, I think this one looks sexier than the one with the girls... Here is the collection of sexy-looking boys. I drew the flowers and berries on a different piece of paper, cut them out, and stuck them on the illustration with glue (the old-fashioned way). The characters with clothes look even sexier. That's a mystery...

21 — *Ribon*, May 2005, Title Page

I just had to draw the sea...so I drew it. By the way, Haine-chan is not walking on the rocks, she's supposed to be floating a little above them. The sea and rocks are in watercolor. Blue watercolor gives a different feel than blue ink, so it's very nice.

THE GENTLEMEN'S ALLIANCE CROSS

Arina Tanemura Illustrations

14 — *Ribon*, Dec. 2006, Title Page
I had a hard time drawing the window in this. I drew the reflection in the window, colored it, and then pasted colortones into the window glass. I think I've been able to nicely express the skirt flowing in the wind, and I'm very satisfied with that. I think the flowers have been colored nicely too.

6 — *Ribon*, Mar. 2007, Title Page
I used mermaid paper for this. (I normally use canson.) This was during the Ushio arc, so the title pages at that time were all of Ushio and Haine-chan together. If you look at it carefully, the two images overlap each other and are slightly transparent. I made the outline thinner by mixing water in the ink. I just love the color pink.

15 — *Ribon*, May 2007, Title Page
I have special feelings for this illustration. It's a pity that the color turned out darker than I expected. The grooves on the wall have been drawn well, so please take a look at it. For some reason the people at the editorial department tell me the color is scary whenever I use purple for shadows. This was the last title page of the Ushio arc.

10-11 — *Ribon*, Dec. 2005, Title Page
My supervisor back then was aghast at the color and told me it looked scary. For some reason they're wearing fantasy-like clothing. (Why?!) I was hooked on drawing accessories back then. Also, please pay close attention to the strange-looking flowers. I'm very glad that this illustration is popular among my fans.

7 — *Ribon*, Feb. 2005, Title Page
If you look carefully, Haine-chan has taken her jacket off and placed it over her shoulders. To tell the truth, I spilled the ink I was using to draw the outline on the paper, so I hid that when I was finishing the illustration up. The leaves around the edge were drawn in watercolor. It's got a wintery feel to it. I wanted to draw something "white."

16-17 — *Ribon*, Dec. 2005, Furoku Poster
This was an illustration I drew because I just simply wanted to draw jewels, but it turned out plainer than I had imagined…The dress Haine-chan is wearing is the one she was wearing at the ball. This was a dress designed by one of my fans, so I wanted to draw it again.

12 — *Ribon*, Oct. & Nov. 2007, Third Anniversary Prize Illustration
This was the favorite illustration of the title page designer for *The Gentlemen's Alliance †*. I pasted colortones in the background and used a utility knife to carve out the wing. The point of this illustration is the white leggings Haine-chan is wearing. This was the illustration on the mounting board for the Gentlemen's Alliance stamps.

8 — *Ribon*, Feb. 2006, Title Page
I'm very pleased with the color and texture of Haine-chan's skirt. I worked hard on the scarf around her neck, so please look at that too. I actually drew the outline in a light color, and then drew over that with a darker color. It took a lot of time, but I really wanted to do it.

THE GENTLEMEN'S ALLIANCE CROSS

Arina Tanemura Illustrations

13 — *Ribon*, Sept. 2005, Title Page
An ensemble of an older sister, a younger sister, and younger brothers. ☆ The fad back then for me was to use watercolor and give it a foggy look. Tachibana was a very refreshing character for me since I hardly ever have young children in my manga. The reason Haine-chan is drawn in close-up is because…she's always on top of the other three.

9 — *Ribon*, Dec. 2004, Title Page
This is one of my favorites from my earlier illustrations. Now that I look at it, I think the color is a little too bland. I wanted to give the background a gradation of bluish purple to emerald green, but it was a lot more difficult than I thought.

THE GENTLEMEN'S ALLIANCE CROSS
ILLUSTRATIONS

The Gentlemen's Alliance † was serialized in *Ribon* magazine from September 2001 through July 2008. Arina Tanemura personally picked 86 illustrations and wrote comments for all of them!

Cover — Newly Drawn

I decided from the start to make *The Gentlemen's Alliance †* art book using blue tones. But there actually aren't a lot of illustrations from the series in blue. There's also something fresh about the characters wearing different clothes in this. I wanted to give this illustration a cool image, so Haine-chan isn't smiling. I'm very satisfied with it. The reason Ushio is the second most visible is because she's the most popular of the five characters. She's been the most popular since the very first chapter.

1 — Arina Tanemura Calendar 2005, Front Cover

This would be the illustration I have in mind when I think of *The Gentlemen's Alliance †*. I drew this for the front cover of the calendar. It's Takanari-sama, not Haine-chan, who's in the center of the illustration, and that's something I like about it. The background took a long time…!

Cover Flap — *Ribon*, May 2005, Furoku CD Jacket

This was an illustration for the magazine supplement. I'm very fond of it. Takanari looks a little grown up in it, doesn't he? I drew the illustration starting with the background, which was colored using the Copic Airbrush System. Then I drew the image using a brush with color ink, without doing a rough sketch first. I drew this with the image of a garden in mind.

Cover Flap — *Ribon*, Sept. 2004, Series Announcement Illustration

This is the illustration used with the announcement for the series. I had decided, "It'll be an illustration of the two doing a kick!" I don't know why. I worked hard so that Haine's underwear wouldn't show. My supervisor at the time told me that the image had a strong impact.

2-3 — *Ribon*, Sept. 2004, Title Page

I know it's too late now, but why is Haine-chan holding a sword…? It's probably because I wanted to make her seem strong. This illustration was on a poster that was given out to ten thousand people as a present to commemorate the start of my new series. Do any of you have it?

Poster 1 Back — *Ribon*, July 2008, Title Page

I drew it like a photo album with all the feelings I had in the last chapter. The color didn't turn out the way I wanted it to, but I think it became an illustration fit for a final chapter. Haine's expression became a lot kinder than I had expected. Best wishes to all the characters.

Poster 1 Front — *Ribon*, June 2008, Title Page

I used mermaid paper. The color pink comes out very nicely on this paper. I was very happy since I had never drawn an illustration of the three being happy together. I wonder why Takanari ends up looking like the older brother when the three of them are together.

4-5 — *Ribon*, Oct. 2004, Title Page

I tend to be embarrassed by my old illustrations, but I like this one since it fits the series very nicely. If I remember correctly, I took a week to color this… I especially took my time with the part-time worker trio. I thought, "Whoa, the school doctor looks evil in this…"

Poster 2 Back — *Ribon*, June 2008, Cover

I had a strong desire to draw an illustration with all five of them together, and I had been asking the editorial department to let me do one ever since the series started. (But if I had drawn this right when the series started, Ushio-chan would probably not have looked like this.) I'm sure you can feel the passion I put into drawing it. This is a memorable illustration for which I received a lot of praise.

Poster 2 Front — *Ribon*, Oct. 2008, Title Page

This is hand drawn so it took a lot of hard work to create all the polka dots. This was the last color illustration for *The Gentlemen's Alliance †* series. I drew Haine-chan really big so I could color a large area of her hair. Whenever I draw an image of someone with their eyes wide open, I often end up opening my eyes wide too when I draw it.

| USIO | HAINE | SIZUMASA | MAGURI | MAORA |

THE GENTLEMEN ALLIANCE CROSS ARINA TANEMURA

MERRY CHRISTMAS

MERRY CHRISTMAS

THE GENTLEMEN ALLIANCE

THE GENTLEMEN ALLIANCE
ARINA TANEMURA RIBON

HAINE
USIO
MAORA

44

37

25

17

CROSS

THE GENTLEMEN'S ALLIANCE

Arina Tanemura Illustrations

THE GENTLEMEN'S ALLIANCE CROSS

ARINA TANEMURA ILLUSTRATIONS

THE
GENTLEMEN'S
ALLIANCE
CROSS
Arina Tanemura
Illustrations